Natural Niagara

A picturesque look at the natural beauty and power of the Niagara River and the Niagara Falls.

Thomas J. Salada

CONTENTS

1 INTRODUCTION

The Niagara River is, no doubt, one of the most diverse and spectacular waterways that is shared between the United States and our neighbors to the west, Canada. The most familiar, and certainly the most popular characteristic of the Niagara River is, of course, The Niagara Falls.

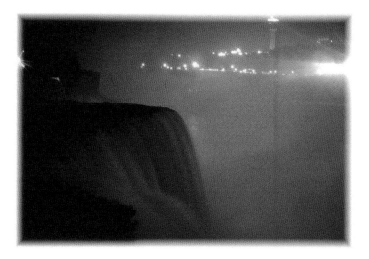

The Niagara Falls are so impressive anyone could overlook the elusive beauty and splendor that flows above and below the falls. The Niagara River and its shoreline are naturally extraordinary in their own right.

The beauty of this river can be seen and experienced by walking along the pathways atop the river's gorge or hiking down through the lower gorge and along the river's edge. Thrill-seekers can take an exciting ride through

the lower rapids on a jet boat, or see the magnificence of the Niagara Falls from aboard one of the tour boats. There are many up-close vantage points to view the upper rapids and The Niagara Falls from Goat Island, Three-Sister Islands, Luna Island, and Prospect Point on The American side of the river.

However you experience The Niagara River, The Niagara Falls, and surrounding areas, you will be treated to stunning vistas, and subtle vignettes that are sure to give you a sense of awe and wonder. Written words and photographs cannot adequately describe or capture the Niagara River's dramatic features and the stunning landscapes that surround the area. It must be experienced.

The Niagara River runs approximately thirty-six miles (58 kilometers) long. It flows from Lake Erie to the south, drastically dropping in elevation, flowing north until finally reaching Lake Ontario.

The Niagara River appears quite ordinary at its source, but the closer it approaches the Niagara Falls the more extraordinary it becomes. Once the river reaches an area known as Goat Island, it is transformed into a raging and dangerous surge of water. These rapids flow fast and furious around Goat Island, down river finally reaching its tremendous pinnacle, the Niagara Falls.

An average of about four million gallons of water rush over the crests of the American and Canadian Falls every minute. To stand and watch the water flow over its brink is both intense and mesmerizing. The water crashes over huge boulders at the base of the falls with a thunderous roar; churning up great clouds of mist that can be seen for miles around.

Over the centuries, the Niagara River has carved its way through the Niagara Gorge creating a natural border between the United States and Canada. At various points along the river's path, the gorge walls reach heights of more than three-hundred feet.

As the Niagara River courses through the gorge other powerful spectacles can be encountered including the lower river rapids and the Niagara Whirlpool. The lower rapids and the whirlpool were created by a sharp right turn in the river, which has created fierce undercurrents. The lower rapids and whirlpool are as treacherous as they are powerful and turbulent. The Niagara River flows swiftly on its way for several more miles until ultimately emptying into Lake Ontario.

The Niagara River and the areas along its shores run rich with history and folklore. Over the years, the river has been a boon to industry, the production of hydro-electric power, and tourism. The river has also been an attractive challenge to daredevils and thrill-seekers alike. Sadly, these waters have also claimed the lives of many people, some by terrible accidents, some by tragic choices, and others by daring to defy these dangerous waters.

The Niagara River and surrounding areas run rich in natural beauty and charm. One must simply look beyond the obvious in order to find the abundance of subtle splendor and dramatic power that embraces the area. It can be found during all seasons, day or night. It may show itself as ordinary, awesome, as wild, or serene. This natural grandeur can be found all along the course of the Niagara River and its shores.

2 UPPER NIAGARA RIVER

One of the more natural and picturesque areas along the upper Niagara River is a place called Goat Island. You won't find any goats on the island these days, but what you will find are riveting vistas and striking scenery.

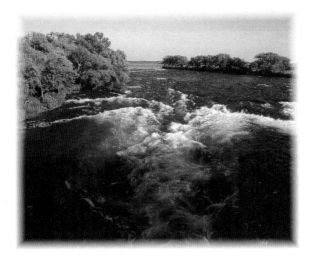

Goat Island, according to local history, received its name from a British settler by the name of John Stedman. Stedman kept his livestock on the island to protect them from predators. As the story goes, one of Stedman's goats had survived an especially harsh winter on the island. If you have ever experienced a Western New York winter, then you can appreciate the tenacity of this tough old goat. So, Stedman then decided to name the island after his goat. His goat may be long gone, but the name of the island has remained to this day.

Natural beauty surrounds the island as do the raging upper Niagara River Rapids. Spectacular views of the rapids crashing their way toward the falls can be seen from almost any place along the island's shores.

The upper Niagara River is also dotted with small yet graceful waterfalls and unique rock formations. Pathways lined with a variety of trees, plants and shrubbery lead you out to the edges of the island for striking and sometimes dangerous views of the upper rapids.

Wandering about Goat Island you will encounter other smaller islands. The most popular of these small islands are Three Sister Islands. These islands are kept in a natural state. Three Sister Islands are natural rock formations, which have endured the constant battering of the surrounding rapids.

Luna Island, is another small island connected to Goat Island by footbridges and pathways. Luna Island is a tranquil oasis situated between the American Falls and the Bridal Veil Falls.

There are countless vantage points along Goat Island from which captivating and dramatic views of the upper Niagara River, the upper rapids, and the falls can be seen and experienced close-up.

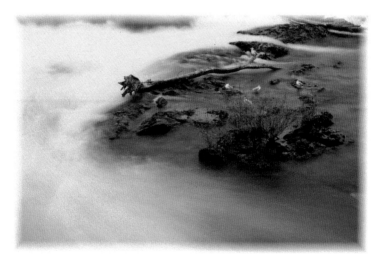

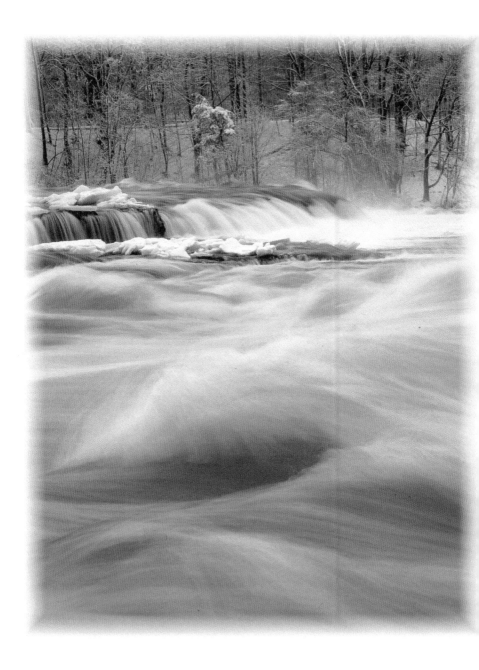

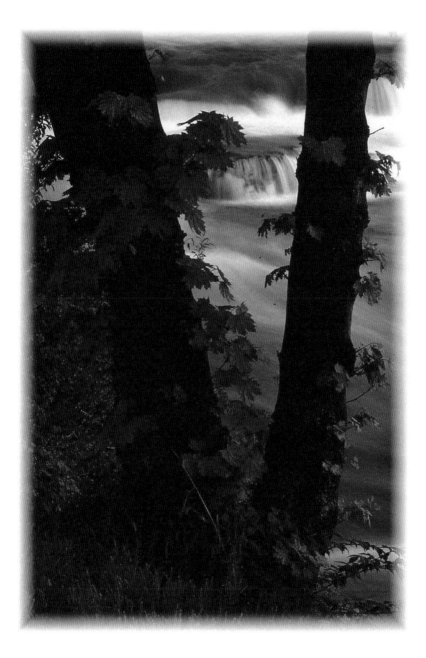

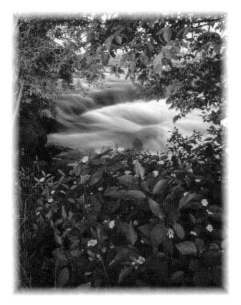

Upper Niagara River rapids as seen from Goat Island.

Small waterfall as seen from Luna Island.

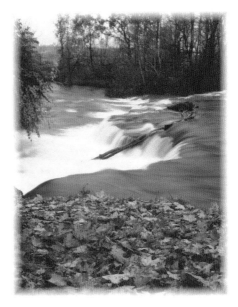

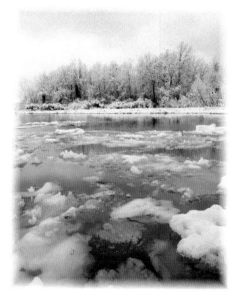

Ice flows down river toward the American Falls.

Autumn colors as seen from Three Sister Islands.

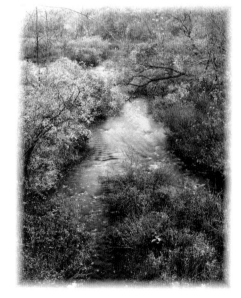

3 THE NIAGARA FALLS

A trip to the Niagara Falls is a must for anyone visiting the Western New York region. In fact, every year millions of people from all over the world come to witness the magnificence and grandeur of these cascades. Anyone who has seen the Niagara Falls will testify that they are an incredible display of nature.

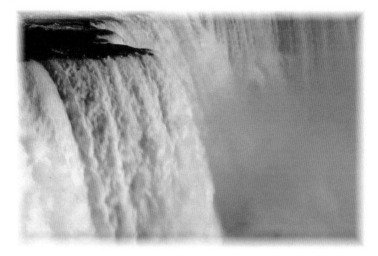

The Niagara Falls are the Niagara River's crown jewel. These falls include The American Falls, the Canadian or Horseshoe Falls, and the Bridal Veil Falls. Approaching the Niagara Falls for the first time, a sense of anticipation may be experienced from the overwhelming feeling that something very powerful is close by. Viewing the Niagara Falls while standing at the guardrail that separates us from the strong current, the onlooker is awe-struck by the unstoppable power flowing only a few feet

away. Gazing upon the falls for the first time, the realization becomes apparent that there is a force mightier than mankind.

As the Niagara Falls flows over its crest, the thunderous roar and sweeping current mesmerizes one into an almost hypnotic state. The gentle mist refreshes as it falls upon your face. Colorful rainbows forming at the base of the falls add a sense of wonder and magic.

It can be a humbling experience to stand so close to something so powerful; to witness nature's continuing saga as it unfolds before your very eyes. A visit to the Niagara Falls will not soon be forgotten. The experience will always be cherished.

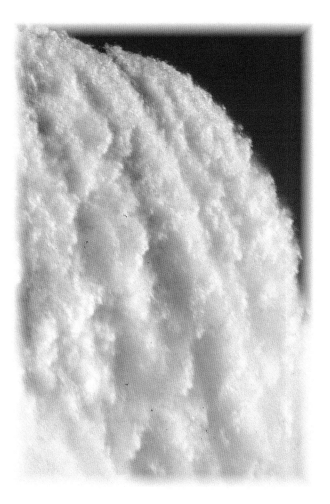

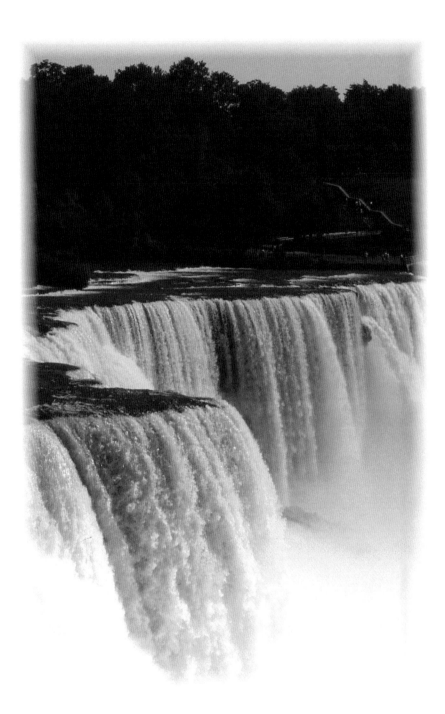

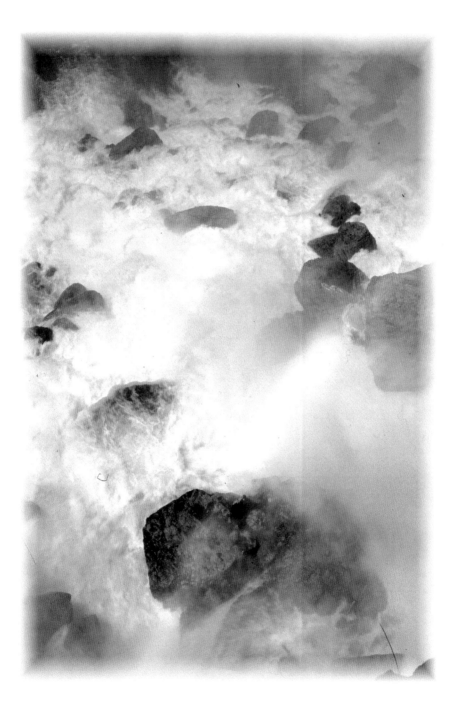

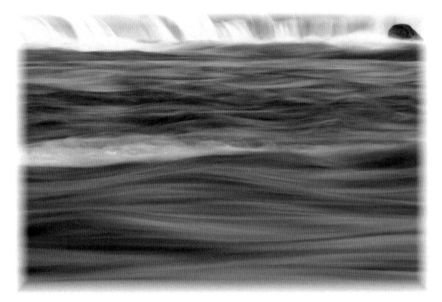

Top: Water flowing over the Horseshoe Falls.

Below: The American Falls after a snow storm.

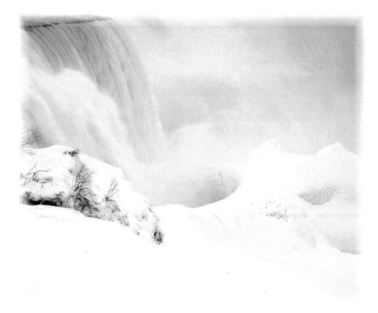

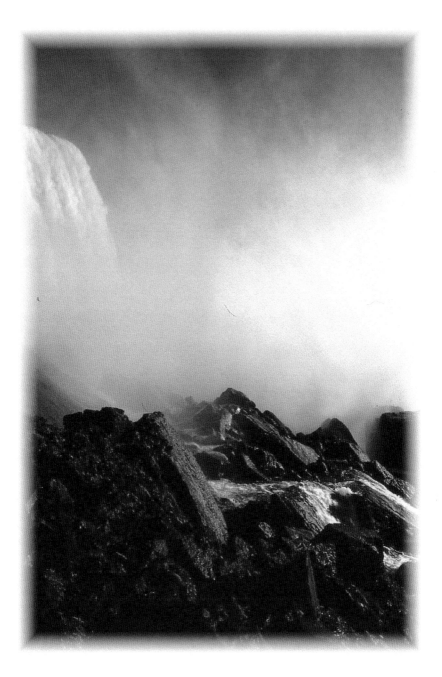

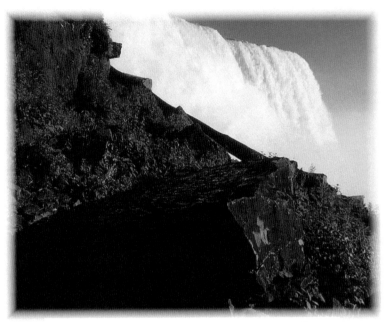

Top: A view from the base of the American Falls.

Below: A view of the Niagara River flowing between
the United States and Canada.

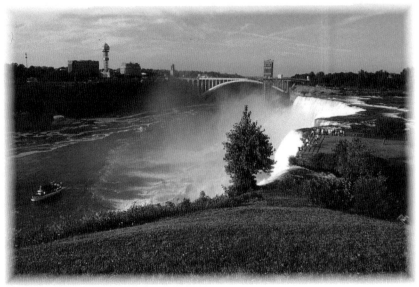

4 THE LOWER NIAGARA RIVER

After the raging waters of the mighty Niagara Falls flow over their crests, they are soon rushing through the lower Niagara River gorge toward the final destination, Lake Ontario.

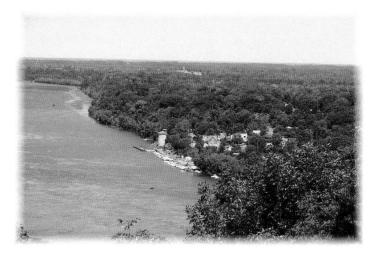

Swiftly flowing down river, the Niagara is once again transformed into another awesome spectacle of nature, the lower rapids and the Niagara Whirlpool. This section of the river was created by a sharp right turn through the gorge. The lower rapids and whirlpool are a formidable part of this waterway. The strong current and undercurrents make this section of the river quite dangerous and unforgiving.

Flowing out from the whirlpool's powerful current, the Niagara River carves its way through the lower Niagara Gorge. This part of the lower river is quite tame compared to the rest of the upper river, but its currents are still strong as they sweep onward toward Lake Ontario.

Along the way, nature in her most grand as well as her subtle beauty can be seen throughout the river's gorge. Just as the flowing current is ever changing, the scenery along the Niagara's shores is in a state of perpetual change.

During the winter months a blanket of snow covers the bare trees that line the gorge walls. Sparkling ice formations hang from jagged boulders glistening as they slowly melt from the warming sun. In spring the fresh scent of the season fills the air while gentle rains spark new growth. In summer lush greens abound. During autumn, the spectrum of color is as exhilarating as a cool evening breeze.

As one walks undisturbed along the paths and trails through the lower river gorge, listening to the squawking of the gulls, or the rush of the water, or simply enjoying the scenery, a sense of peace and tranquility can be experienced. Venturing further up river the feelings of fascination and awe can be experienced with an up close view of the untamed and fast-moving waters of the Niagara.

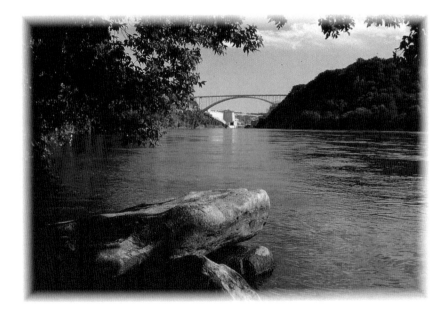

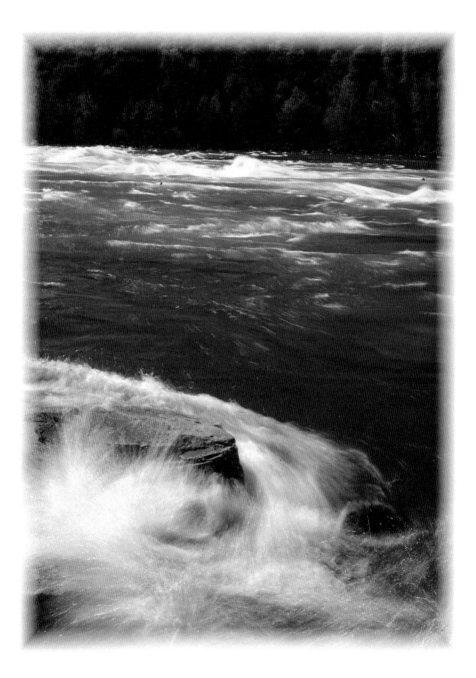

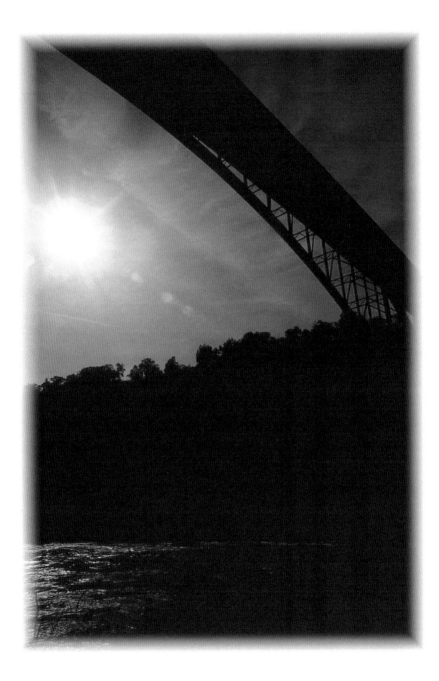

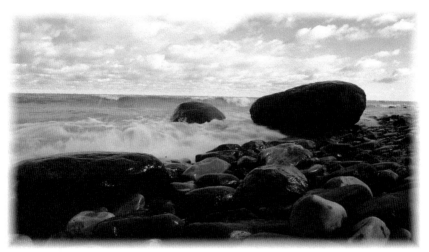

Top: The shore of Lake Ontario.

Below: Views of the strong currents of the lower
Niagara River.

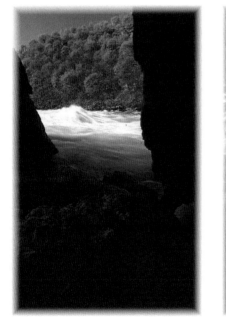

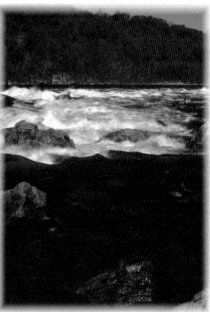

5 WILDLIFE

On any given day on Goat Island, in all types of weather you can encounter people involved in all types of activities. Joggers, walkers, picnickers, sight-seers, photographers all taking full advantage of the wonderful setting of the island and the Niagara River.

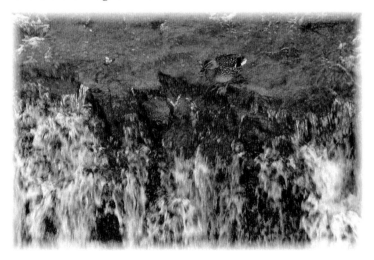

In the midst of all of this, there are a hardy assembly of inhabitants who endure all kinds of weather year round. You can find these islanders basking in the sun, bathing in the cool waters, foraging in the woods, or perched atop tree. Sometimes you won't have to find them at all, they will find you seeking a morsel of food. These inhabitants are the many species of birds, squirrels, and other animals who call Goat Island their home.

There are a wide variety of birds on the island. The most popular spot for them is near the Three Sister Islands. Here ducks, mallards, gulls and mourning doves, to name a few, can be found enjoying the soft flowing currents and shallow pools that run between the islands. Hundreds of birds congregate around this area competing for food and sometimes mates.

Some of the most popular inhabitants of the island are the squirrels. Grey and black squirrels can be seen playfully chasing each other from tree to tree, or digging for buried treasure. The squirrels roam the island uninhibited sometimes approaching a passerby hoping for a treat.

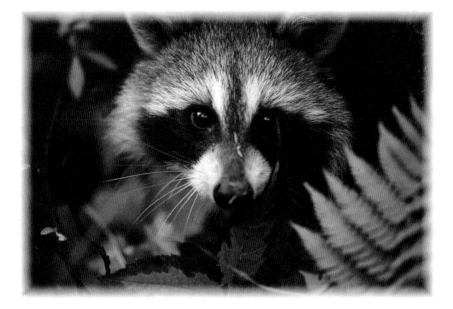

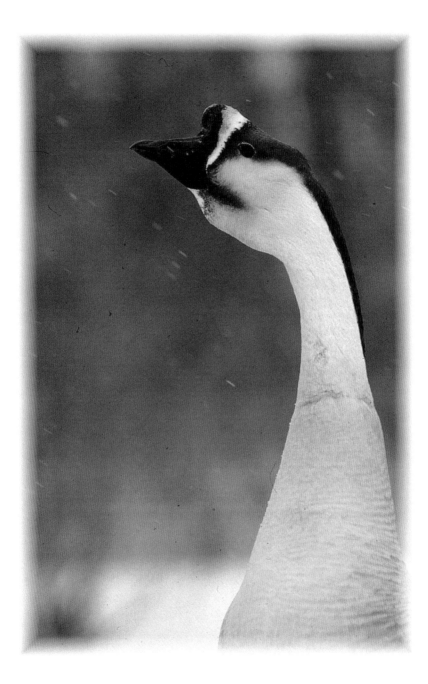

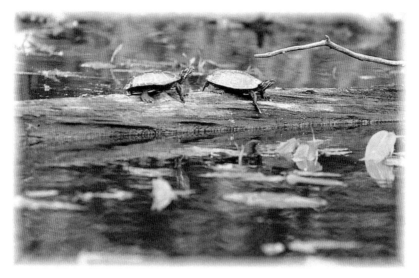

Top: Turtles near the shore of Lake Ontario.

Below: A Mourning Dove during winter on Goat
Island.

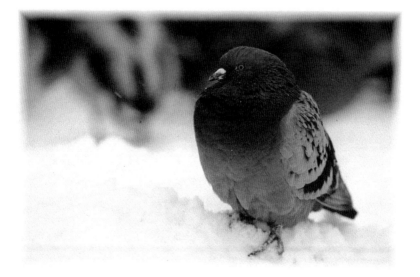

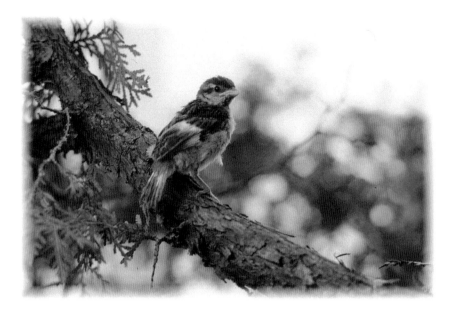

Top: A Finch perches atop a tree limb on Goat Island.

Below: A Black Squirrel enjoying a midday snack.

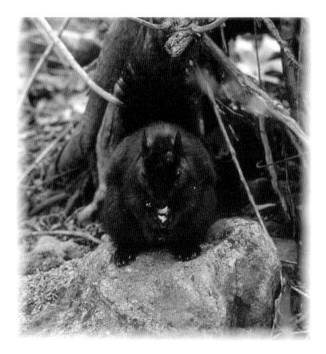

6 ON NATURE

To appreciate nature, we must learn to open ourselves to the beauty that is in all creation. We must learn to open our hearts and minds to appreciate the place that we share with all creation.

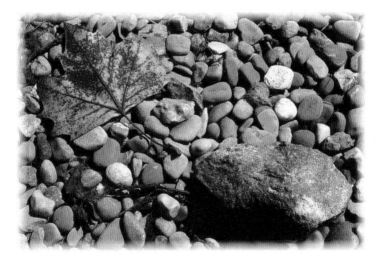

We become humbled in the knowledge that our very existence depends upon the air we breathe, the water we drink, the soil we till, and the indispensible role that all species of animals, fish, birds, and insects play in the natural order of life.

Mankind is slowly becoming aware that we must harmonize and accept nature in all of its forms rather than attempting to control and change nature. Our existence alone should be reason enough for us to appreciate and protect nature.

In true appreciation of nature we can see the greatness in the mountains, the mystery of the seas, the power in the weather, and the nobility of the forests. We can see perfection in all that exists, and all that has been created for the mutual benefit of all species and of all nature. To appreciate nature is to realize that it is the life-giving force that surrounds us. Nature is an outward sign of the perfection of its creator.

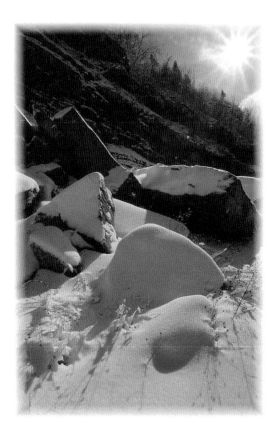

Top: Winter's landscape in the lower Niagara Gorge.

Below: A blooming pussy-willow bud.

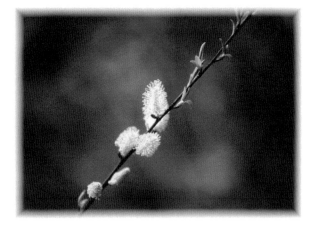

The turning colors of autumn can be seen on a path from Goat Island.

Water lilies near Lake Ontario

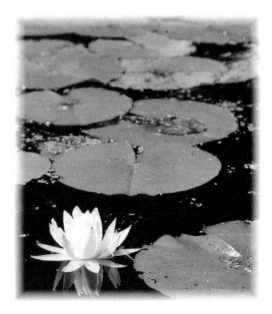

ABOUT THE AUTHOR

Thomas is a retired professional photojournalist. He holds a BA in Journalism and Communications, and a Diploma in Photographic Studies.

Thomas Salada is also the author of *The Human Race Will Let You Down… Dogs On The Other Hand.*

Made in the USA
Charleston, SC
27 December 2014